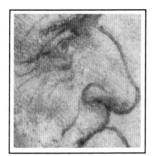

THE ART OF
FLORENTINE DRAWINGS

Edmund Swinglehurst

A Compilation of Works from the

BRIDGEMAN ART LIBRARY

SMITHMARK

The Art of Florentine Drawings

This edition published in 1996 by SMITHMARK
Publishers, a division of U.S. Media Holdings, Inc.,
16 East 32nd Street, New York, NY 10016.
SMITHMARK books are available for bulk
purchase for sales promotion and premium use.
For details write or call the manager of special
sales, SMITHMARK Publishers, 16 East 32nd
Street, New York, NY 10016; (212) 532-6600
First published in Great Britain in 1996 by
Parragon Books Limited
Units 13-17, Avonbridge Industrial Estate
Atlantic Road, Avonmouth, Bristol BS11 9QD
United Kingdom

ISBN 0-7651-9894-0

Printed in Italy

Editors: Barbara Horn, Alexa Stace, Alison Stace, Tucker Slingsby Ltd
 and Jennifer Warner

Designers: Robert Mathias • Pedro Prá-Lopez, Kingfisher Design Services

Typesetting/DTP: Frances Prá-Lopez, Kingfisher Design Services

Picture Research: Kathy Lockley

The publishers would like to thank Joanna Hartleyat the Bridgeman Art Library
for her invaluable help.

FLORENTINE DRAWINGS

The art of the 15th and 16th centuries in Florence expressed a deep cultural change in Italy and much of the rest of Europe, which would eventually led to what historians call 'the modern world'. The stiff hieratic forms of medieval art, which mirrored the society of that time, were being replaced by the free, searching techniques of the new society, in which curiosity about the world replaced accepted doctrine and man ceased to be a mere cog in a fixed God-created structure and became instead a free-thinking creature through whom truth, beauty and intelligence could shine.

For the artist, the foundations of the new art lay in draughtsmanship. In drawing, either in silver point – that is, using a rod of silver on a prepared ground, black chalk or red chalk, sometimes called 'sanguine', or wash, a kind of watercolour, he could explore the means of changing the two-dimensional picture of the world into one with three dimensions and spacial atmosphere.

A major historian of this change was Giorgio Vasari, a painter and friend of the Medici rulers of Florence, who chronicled the lives of his contemporaries in his book *Lives of the Most Excellent Painters, Sculptors and Architects*, usually called in English *Lives of the Artists*. In this unique book, first published in 1550 and re-published in an expanded form in 1568, Vasari recounted through the lives of the artists the story of the rebirth of art after the so-called Dark Ages from Giotto to Michelangelo.

The theme of the book was in keeping with the Renaissance

humanist concept, based on the belief that since man was the centre of the world, then history should instruct through accounts of the lives of the best of them. Vasari's book was a series of biographies, including lengthy explanations of the methods by which the artists achieved their greatness and progressed the achievement of artistic ideals.

This book follows a similar path, beginning with the work of Paolo Uccello whose preoccupation with perspective and design widened the stage of artistic endeavour. Uccello produced for the Medicis epic paintings of battle scenes which astounded his contemporaries and are still a wonder of the world.

Space, as explored through perspective, was one aspect of the new curiosity about man's environment; another was man himself as a three-dimensional inhabitant of this space. The exploration of man, begun through the study of Greek art and culture, prompted an interest in anatomy, such as that seen in the work of Antonio Pollaiuolo, whose vibrant line and energetic anatomical studies opened up a new avenue for paintings of man in action.

A curious anomaly to the onward rush of art developments was Sandro Botticelli who, though evidently influenced by Fra Filippo Lippi and Pollaiuolo in the use of line as a means of expression, kept to a medieval style of flat painting. This may explain why, after his death, Botticelli's work was virtually forgotten until rediscovered in the Pre-Raphaelite period in England.

In the 16th century the stream of art was moving rapidly towards a full modelling of figures through the techniques of chiaroscuro, the contrasting of light and dark, and of *sfumato*, or shading shown by hatching or subtle changes in the intensity of the chalk layer. Sometimes, whole pictures were carried out in a grey monochrome technique called grisaille. The most brilliant exponent of *sfumato* was Leonardo da Vinci, whose drawings in black and red chalk have a subtlety of tone which was unrivalled in his day and still is.

The strong expression of form, with an emphasis on the human figure, came to a peak in Michelangelo, whose knowledge of anatomy and sense of movement and gesture created both great murals and great sculpture. He was Vasari's hero and the first version of *The Lives of the Artists* ended with him, the only living artist in the book.

The world of Florentine drawing did not end with Michelangelo, however, but carried on first in the Mannerist style, which insisted on the primacy of the human figure, though often exaggerated and elongated, then in the baroque style which was a major theme of 17th century art. Both styles may be said to have grown out of the work of Michelangelo, an artist so powerfully original that he influenced his contemporaries and those who came after him.

During the period covered by the lives of the artists in this book, the skill of Florentine artists had become such that commissions from other parts of Italy and abroad became commonplace. For most busy artists, their drawings were of little importance, merely the preliminaries to some greater project. Many more of them would have been lost had it not been for the squirrel-like energy of Vasari, who collected drawings with the intention of publishing them in subsequent volumes of his book – an ambition which was never fulfilled. The indifference to the preservation of drawings and their lack of identification – for artists rarely signed them – makes it impossible to give a date for most of them, while, according to the famous American critic Bernard Berenson who wrote a book about Florentine drawings, even their attribution is sometimes in doubt.

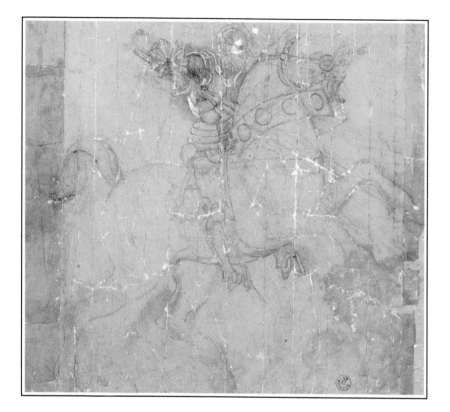

△ **Warrior on Horseback**
Paolo Uccello (1397-1475)

Black and white chalk on blue ground

THE STARTLING PERSPECTIVES of Paolo Uccello's great paintings of battles between mounted soldiers have helped gain him the reputation of having discovered the science which brought painting out of its two-dimensional bondage into the fully rounded forms characteristic of the High Renaissance. In fact, the science of perspective had already been explored by Brunelleschi, the most famous architect in Florence, who constructed the dome of the Duomo (cathedral) in Florence. In this study of a mounted warrior Uccello uses a low viewpoint, such as that of someone looking at a statue on a plinth, and works out the difficult foreshortening. His skill, which was unique at the time, is particularly apparent in the warrior's position and his extended arm.

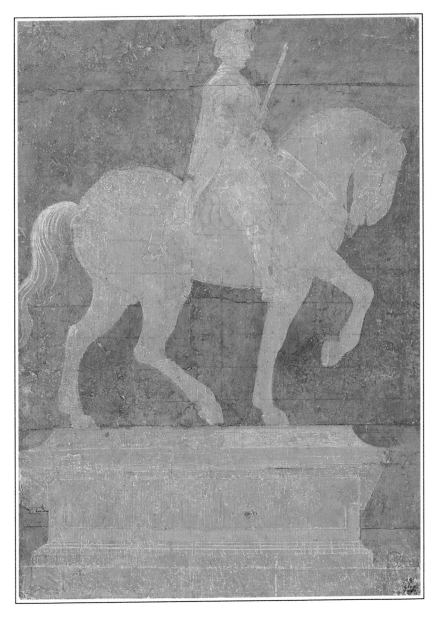

◁ **Study for a Monument to Giovanni Acuto**
Paolo Uccello

Tempera

UCCELLO'S MASTERY of equine form made him the natural choice for studies and designs for equestrian statues. In this case, the statue was never made, though Uccello used the drawing in a mural with a *trompe l'oeil* effect, which still decorates the right transept of the Florence Duomo. Giovanni Acuto was the Italian name for Sir John Hawkwood, a mercenary English soldier in the service of the Medici. The mural was painted in 1436 during the reign of Cosimo, son of the banker who built up the Medici fortunes and made the family the rulers of Florence, with a brief interruption, from the 14th to the 16th century.

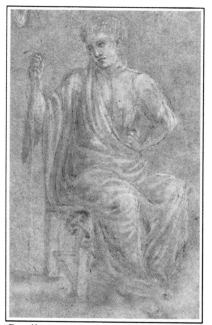

Detail

▷ **Four Figures**
Paolo Uccello

Black and white chalk

THE FIGURE STUDIES in this drawing are more impressionistic than Uccello's studies of horses, and more stylish, approaching the work done by Masaccio in the progress towards realism. Uccello's early training was in the workshop set up by Ghiberti, the creator of the superb bronze doors of the baptistery of the Florentine Duomo, and the gothicism of the master sculptor influenced the young painter. Little is known about Uccello's early work, but this may be because for at least five years he worked as part of a team on the mosaics of St Mark's Church in Venice. In later years his work became less formal and he produced paintings like The Hunt, which foreshadowed the work of the next generation of artists.

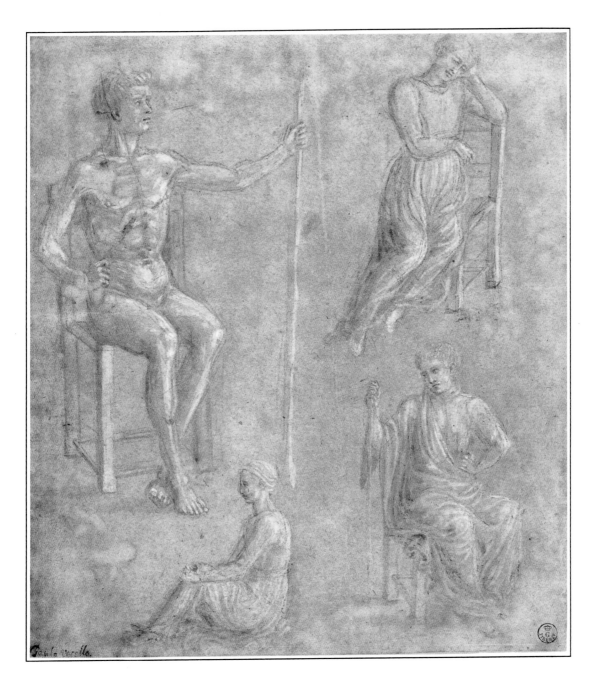

▷ **Profile of a Man Wearing a Turban**
Paolo Uccello

Brown wash

OUTLINING HIS SUBJECT in brown wash, Uccello heightened the drama of the drawing and at the same time expressed with great subtlety the modelling of the features within the silhouette. By doing so, he limited the possibility of experimenting with perspective and foreshortening, at which he became a master and which he used in the *tour de force* battle scenes he painted for the Medici. Despite his success as a painter for the leading family in Florence, Uccello died poor, according to Vasari, and claimed in his tax return that he was old, infirm, unemployed and had a sick wife. This may be a Vasari exaggeration: as late as 1465-9 Uccello was still working on a predella for an altarpiece commissioned by the Urbino Confraternity of the Holy Sacrament.

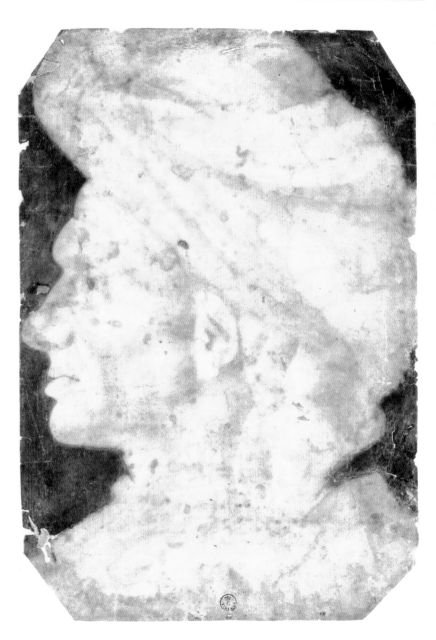

▷ **Female Head**
Filippo Lippi (1406-69)

Black and white chalk

THE DELICATE FEATURES of the young woman who posed for this drawing almost certainly belonged to Lucrezia, the young nun whom Lippi abducted and later married. The same young woman appears in nearly all his paintings of Madonnas and her tenderness of expression tells us a great deal about Lippi's feelings for her. This very fine drawing has a great sensitivity of line which Botticelli, who seems to have been a pupil of Lippi's in the 1460s, must have admired enough to use in his own work. Lippi himself was an apprentice with Masaccio and was the first painter to suggest atmosphere round his figures. This added to the sense of realism which separated painting from its flat medieval style and led to the more realistic one of the High Renaissance. Other influences on Lippi's work were the work of Donatello and Flemish painters.

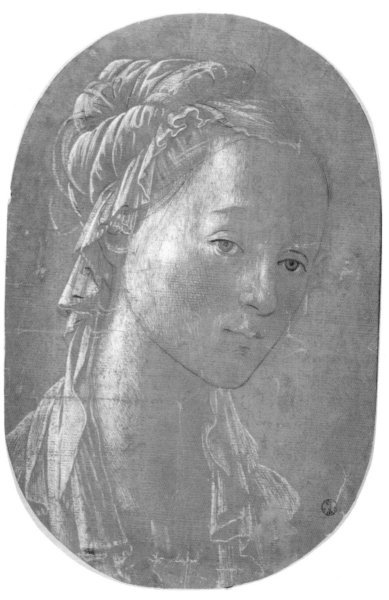

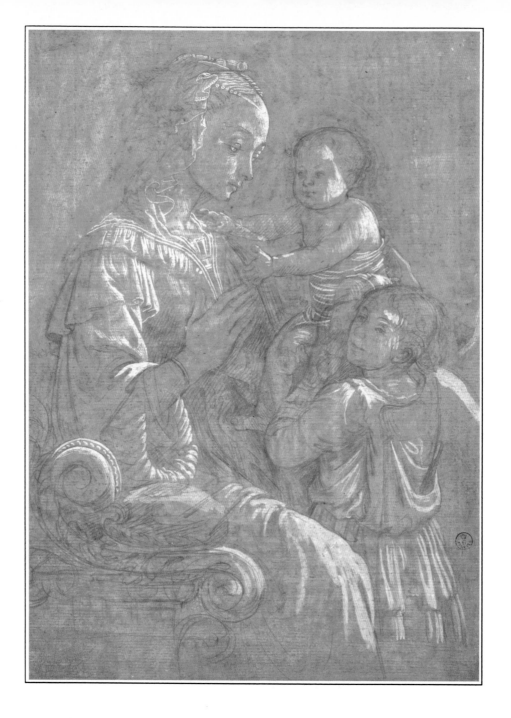

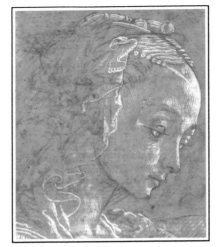

Detail

◁ **Study for a Madonna, Child and Two Angels**
Filippo Lippi

Black and white chalk.

THE MEDICI WERE THE PATRONS of Filippo Lippi while he was still in the Carmine monastery where he had been placed as an orphan, and it was their influence that enabled him to marry Lucrezia. Although not suited to monastic life, Lippi had a deep religious feeling which showed very strongly in his work and which made it possible for him to remain friendly with the religious authorities. He was dedicated to his work as a painter. His sense of space and form, more delicate than that of his master Masaccio, made him much sought-after. Among his finest commissioned work (done on panels) was the *Tarquinia Madonna*, the Barbadori altarpiece and an unfinished fresco in Spoleto cathedral. Among the innovations of style in Lippi's work was the integrating of the figures in triptychs into one composition which spread across the panels.

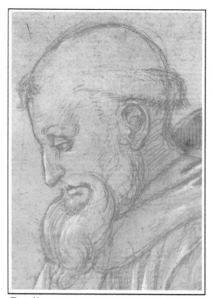

Detail

▷ **Seated Monk**
Filippo Lippi

Black chalk

DESPITE HAVING BLOTTED his copybook with the authorities of the Carmine order, Lippi obtained many commissions from religious orders. In order to complete the assignments, he set up a studio with assistants who, owing to his ill health in later life, took on more and more of his work, particulary in Spoleto Cathedral. After his death, his son Filippino, also a fine painter, completed the Masaccio frescoes at Sta Maria del Carmine. The sensitive linear quality of the elder Lippi's work was thus transmitted through Botticelli, his pupil, to his son who learned his art in Botticelli's workshop. Like his master, Filippino was to know the frustration of seeing his work become unfashionable when Raphael, Michelangelo and Leonardo appeared on the scene.

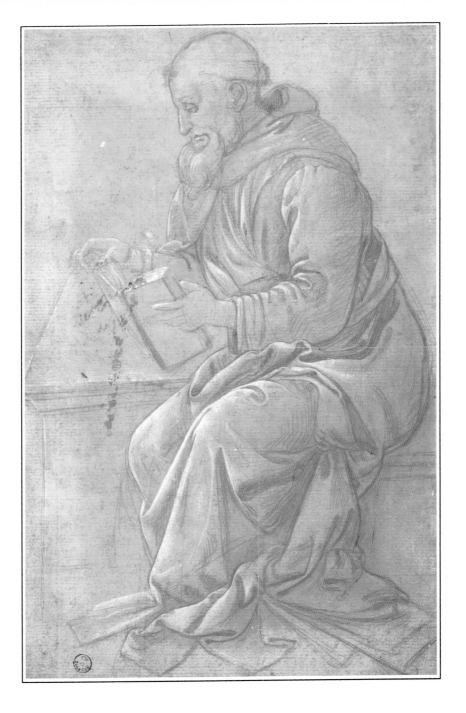

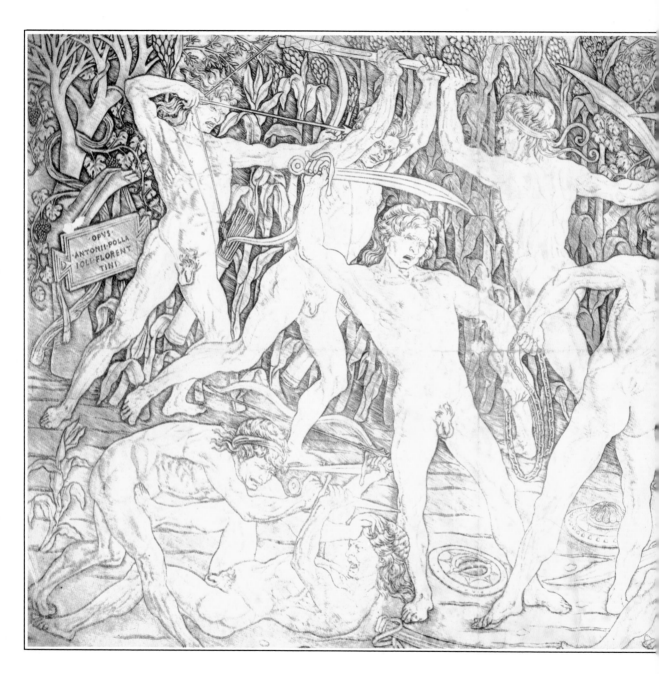

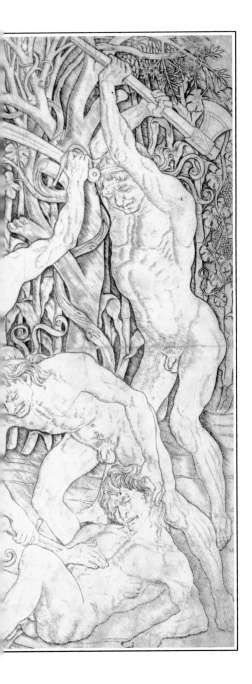

◁ **Battle of the Nudes**
Antonio Pollaiuolo (1432-98)

Engraving

ANTONIO POLLAIUOLO and his
brother Piero were successful
goldsmiths, sculptors, designers
and painters whose Florentine
workshop was one of the seed-
beds of High Renaissance art.
Antonio, the more talented of the
two, was also the more
knowledgeable, having studied
perspective, and personally
dissected corpses in order to learn
more about anatomy. In this
drawing the subject is an excuse
for a study of naked men in a
variety of actions, a foretaste of the
work of Michelangelo. Pollaiuolo,
a master draughtsman, defines
form in this engraving with a line
and hatching technique which was
new at the time. The lively action
depicted by the artist set a new
style in paintings of groups, which
had until then been painted in
static poses.

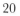

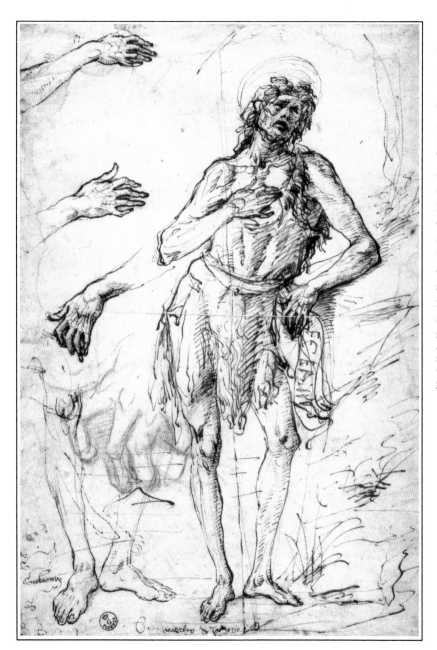

◁ **St John the Baptist**
Antonio Pollaiuolo

Pen and ink

THE NERVOUS PEN LINES of this drawing are evidence of the speed and sensibility of Pollaiuolo's work. Though he has used hatching to express form, the line itself by its different intensities and interruptions gives a three-dimensional image and atmosphere which was rare at the time, but which Leonardo was to exploit fully later. The lively closer studies of hands and feet are remarkable for their precision and anatomical exactness. The sculptural quality of the drawing is probably due to the influence of Donatello, whose work Pollaiuolo greatly admired.

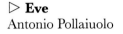

▷ **Eve**
Antonio Pollaiuolo

Pen and ink

THE FINE LINE OF EVE'S body in this drawing is the ancestor of the line drawings of much later artists like Matisse and Picasso. There is very little interior modelling, either by wash or hatching, and the body's fullness is suggested by the subtle changes in the line alone. This control of line is another indication that, of the two Pollaiuolo brothers, Antonio had a greater feeling for sculptural form while Piero's looser handling was more suited to painting. Bernard Berenson, the noted art critic and expert on Florentine and Sienese painting, refutes this, however, claiming that Antonio was just as good a painter as his brother. Antonio's other talents included engraving and embroidery design, a profitable occupation at a time when rich fabrics were worn to denote status and wall tapestries were common in the homes of the ruling classes.

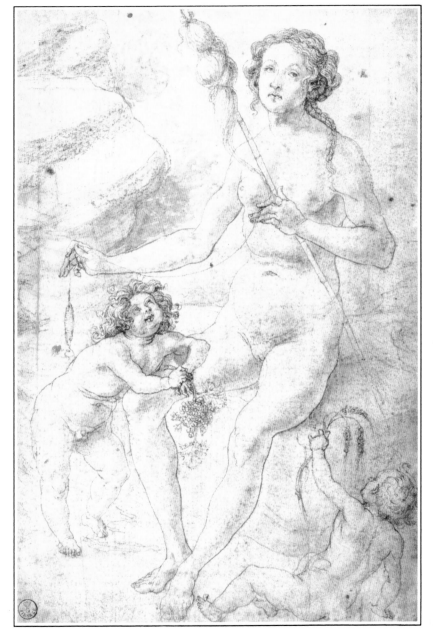

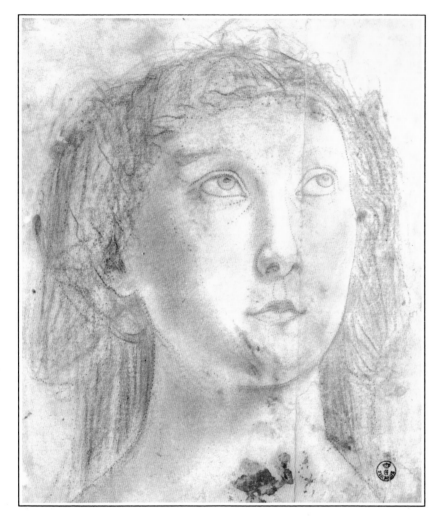

◁ **Study of Head for Faith**
Piero Pollaiuolo (1443-96)

Black and red chalk

THE LESSER TALENT of Piero
Pollauiolo compared to that of his
brother Antonio is evident in this
drawing, though this did not
diminish demand for Piero's work
in his lifetime. Judging by the
perforations, this drawing was
transferred on to a fresco wall by
the pinprick method for one of the
many commissions the Pollaiuolo
workshop attracted. Piero was a
pupil of Andrea Castagno, who
was an influential painter of the
generation after Masaccio and an
admirer of Donatello, whose
emotional and linear style also
influenced the young Piero. His
early style can be compared with
that of the young Botticelli in the
series of *Virtues* which hang in the
Uffizi Gallery in Florence.

▷ Nude Back View
Luca Signorelli (1441-1523)

Black and red chalk

THE ANATOMICAL STUDIES of Luca
Signorelli show the influence of
the Pollaiuolo brothers, though he
was said to have been a pupil of
Piero della Francesca, the
Umbrian painter. Since 15th-
century Florence was brimming
with new artistic ideas it is likely
that Signorelli also picked up
other influences from such artists
as Donatello and Verrochio. In the
1480s, Signorelli worked in Rome
with Perugino, another of Piero
della Francesca's pupils, on the
Sistine Chapel and in 1499 he was
commissioned to complete the
decorations in Orvieto cathedral
which Fra Angelico had begun in
1447: *The Last Judgement* became
Signorelli's greatest masterpiece.
The individual character of his
work is based on vigorous action
in which anatomy plays an
important part – as in this
drawing in which the musculature
of the model foreshadows the
work of Michelangelo.

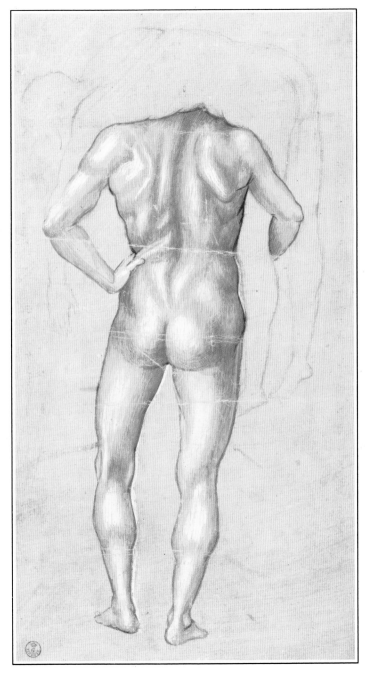

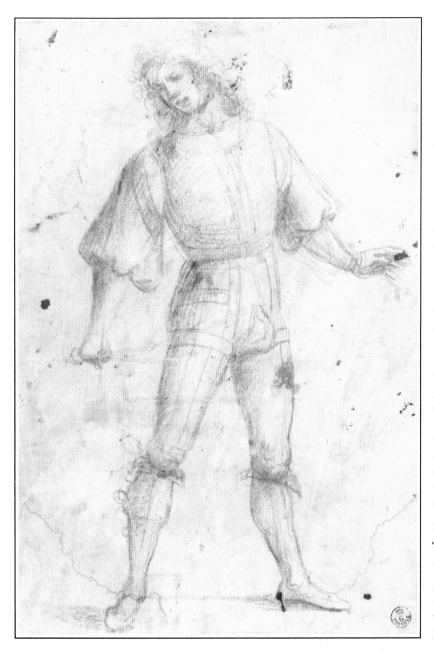

◁ **Man with Breastplate**
Luca Signorelli

Black chalk

THE MAN WITH A DRAWN SWORD
and menacing expression on his
face is typical of the work of
Signorelli, who saw the world in a
harsher light than, for example,
Filippo Lippi. This may have been
the result of the hard times though
which Florence was passing:
Charles VIII of France had
invaded Italy in 1494 and the
chaos of the influence of the
reformist monk, Savonarola, who
was burned at the stake in 1498,
had split Florentine society into
warring factions. Towards the end
of this eventful decade Signorelli
was engaged on the series of
frescoes in Orvieto cathedral
depicting *The End of the World, The
Fall of the Antichrist* and *The Last
Judgement*, which are among his
best work. This drawing in soft
black chalk is, despite its subject,
gentle in technique with its soft
outlines and *sfumato* shading,
which Leonardo later used to
great effect.

▷ **The Damned**
Luca Signorelli

Black and red chalk

THE VIOLENT FATE of those condemned to hell, a strongly emotional theme in the Florence of Savonarola, is presented here by Signorelli in a scene with the kind of brutal action familiar to modern eyes through the realism of photography. In Signorelli's time, drawings and paintings were the only way to bring home to people the idea of the punishments that would come to them through wrongdoing or disobeying the rules of the Church. By emphasising the musculature of the figures with black and red chalks, Signorelli has expressed the animal as well as the human nature of both victims and aggressors. After the upheavals of Florentine life were over Signorelli went to Rome. By now, his vitality had diminished and he was no match for vigorous artists like Raphael and Michelangelo.

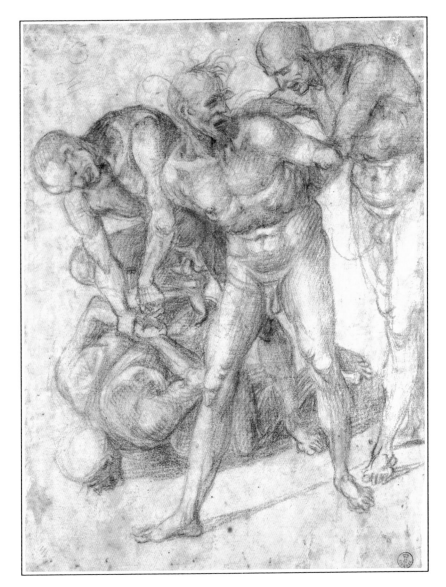

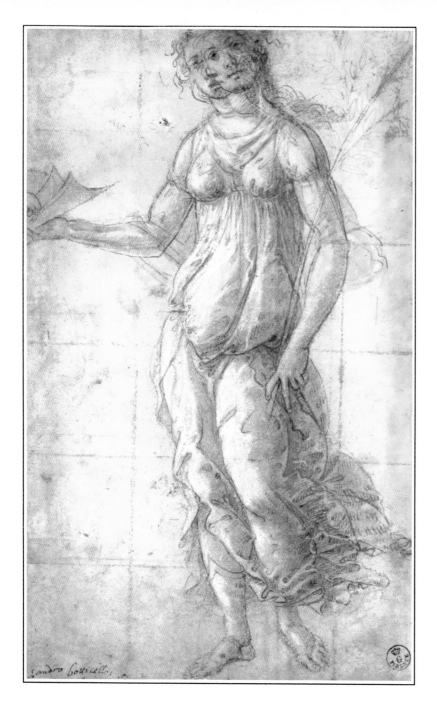

◁ **Pallas**
Sandro Botticelli (1444-1510)

Pen, red and white chalk

THE INFLUENCE OF LIPPI and the
Pollaiuolo brothers is evident in
Sandro Botticelli's early work,
though it is not known for certain
how close he was to the circle of
artists under the patronage of the
Medici. The linear style which he
developed was a mixture of the
medieval and its modern
Florentine developments; it was a
readily acceptable halfway house
and Botticelli was not short of
work. His first commission
included work on *Fortitude*, one of a
series of the Virtues which Piero
Pollauiolo was painting in about
1470. The changed position of the
head in this drawing illustrates the
care Botticelli took in finding the
exact relationship of the parts of
the body in order to create the
fluid and elegant bodies
characteristic of his work.

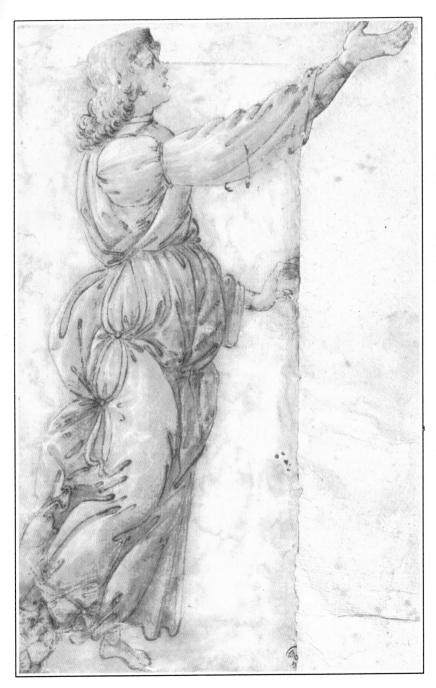

◁ **Angel of the Annunciation**
Sandro Botticelli

Pen and red chalk

THIS ANNUNCIATION ANGEL has
the graceful lines typical of
Botticelli's style; though popular at
first, it came to seem too bland
when Michelangelo arrived on the
scene, consigning Botticelli to a
neglect that lasted 250 years.
During his years of success
Botticelli painted in the Sistine
Chapel in Rome alongside
Ghirlandaio, Signorelli and
Perugino and was commissioned
to paint numerous tender and
devout Madonnas. He also
painted sexually ambiguous
portraits of young men, which
may be the reason he was accused
of homosexuality, a crime for
which he was not prosecuted,
perhaps due to the influence of
the Medici.

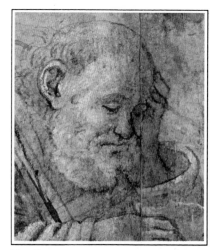

Detail

▷ **Nativity**
Sandro Botticelli

Pen and chalk

THIS STUDY FOR THE CENTRAL figures of a Nativity does not coincide with the several well-known paintings on the subject which Botticelli did, but it could have been a preliminary sketch. Most of Botticelli's Nativities were earlier than the famous secular paintings, Primavera and The Birth of Venus which he made for a Medici who had quarreled with the great Lorenzo over a debt. Botticelli's relationship to the Medici is not clear, though in one of his Nativities he included Cosimo, Lorenzo and Giuliano among those paying homage to the infant Christ. His attitude towards Savonarola is also obscure, but when the monk was burned at the stake Botticelli underwent some spiritual turmoil. Vasari claims that at the end of his life Botticelli became ill and poor, which suggests that he no longer had the support of his former patrons.

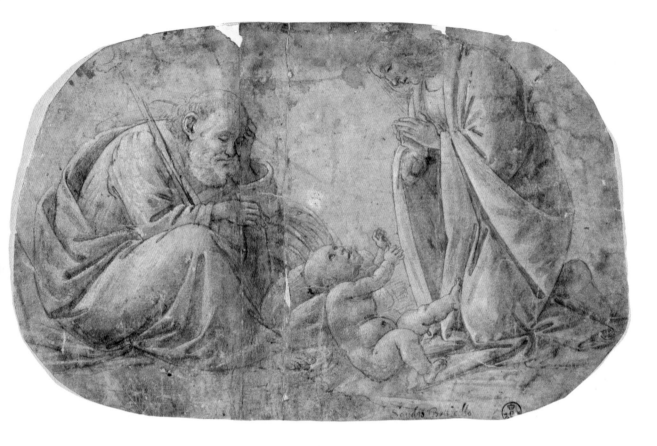

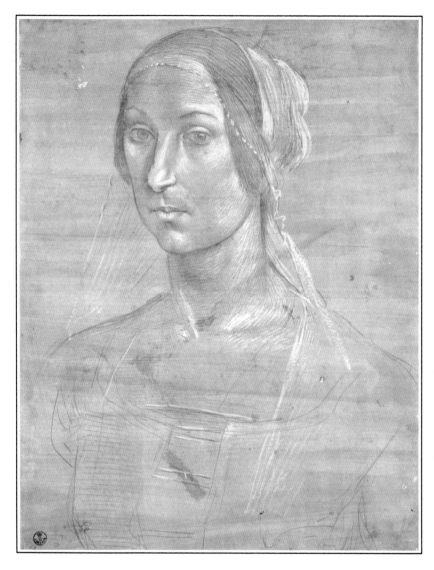

◁ **Woman's Head**
Domenico Ghirlandaio (1449-94)

Black and white chalk

THE WORKSHOP RUN BY
Domenico Ghirlandaio and his
brother Davide and other relatives
was one of the most productive in
Florence and employed numerous
apprentices, including
Michelangelo. Ghirlandaio was a
good businessman as well as an
artist and preferred painting in
fresco and tempera to oils. He
therefore undertook a considerable
amount of mural work, including
some in the Sistine Chapel in
Rome. In his work there,
Ghirlandaio, perhaps with an eye
to business contacts, included large
numbers of influential Florentines,
who happened to be in Rome, in
the painting of the *First Apostles*.
His pragmatic approach to art did
not endear him to the Medici and
his drawings, like this one, had the
kind of realism that appealed to
the average member of the public
rather than the connoisseur.

▷ **Young Girl**
Domenico Ghirlandaio

Pen and ink

THE FIGURE OF THE YOUNG GIRL
in her swirling dress is a good
example of the charm and
competence of Ghirlandaio's
work, though it shows a certain
lack of sensitivity in the handling
of the folds in the drapery.
Ghirlandaio's success as a mural
painter in Florence seems to have
due in part to his conventional
and easily accessible style which
reassured those who were
commissioning his work, and in
part to the fact that he had worked
alongside Pollaiuolo, Verrochio
and Botticelli on the Sistine
Chapel frescoes. Most important
of all was the fact that Ghirlandaio
was a protégé of the Medici,
whom he had pleased by including
them in frescoes in the choir of Sta
Maria Novella, work
commissioned by Giovanni
Tornabuoni, who was related to
the Medici by marriage.
Ghirlandaio lived and worked
largely in Florence, where his
paintings may be seen in
numerous churches.

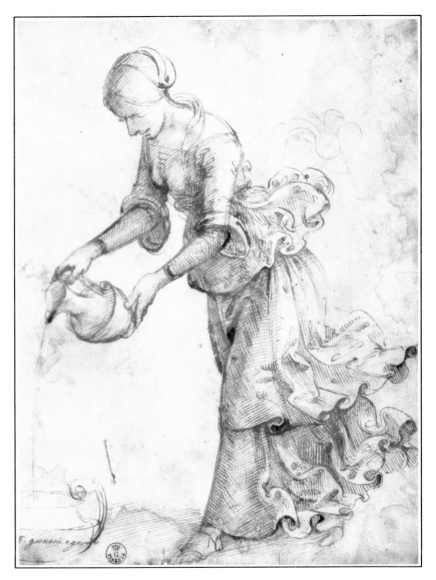

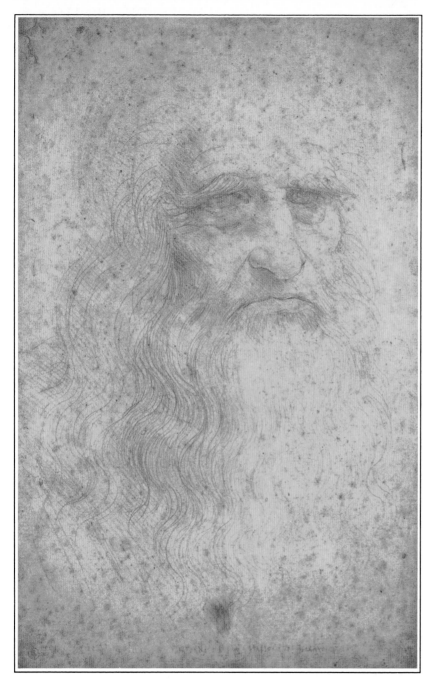

◁ Self-Portrait
Leonardo da Vinci (1452-1519)

Red chalk

DURING THE RENAISSANCE it was not unusual for artists to work in a variety of fields from jewellery design to architecture. None of them equalled Leonardo da Vinci in versatility, for his genius touched every imaginable subject including anatomy, aeronautics, botany, engraving, painting, fortifications and weapon design. His life spanned the High Renaissance, of which he was one of the creators. His main failing was that the multiplicity of his activities prevented him from completing many of his projects. Born in Vinci, near Florence, Leonardo began his artistic life as a pupil of Verrochio. From there, he progressed to his own style which became much in demand with the Pope and the kings and princes of Europe, including Francis I of France, who provided Leonardo with a house and studio called Clos Luce near the Chateau of Amboise. Models of Leonardo's inventions can be seen in the house today.

▷ **Woman's Head**
Leonardo da Vinci

Black and red chalk

THIS HEAD OF A WOMAN, which is instantly recognizable as a drawing by Leonardo, is a superb example of his astonishing powers of observation and his skill in reproducing his vision on paper. The subtlety of modelling of the eye, lips and mouth is superb. It goes some way to explaining why his appearance on the artistic scene cast such a shadow over his rivals, though most of them did not, as his master Verrochio is said to have done, give up painting for sculpture. In all his portraits Leonardo's keen sense of the psychology of the sitter is apparent – including the famously tantalising one now called *Mona Lisa*.

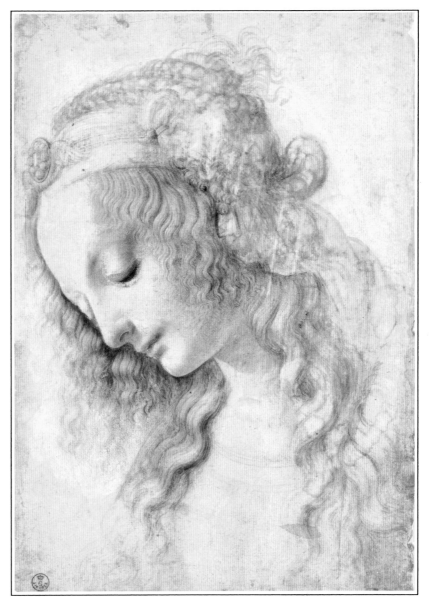

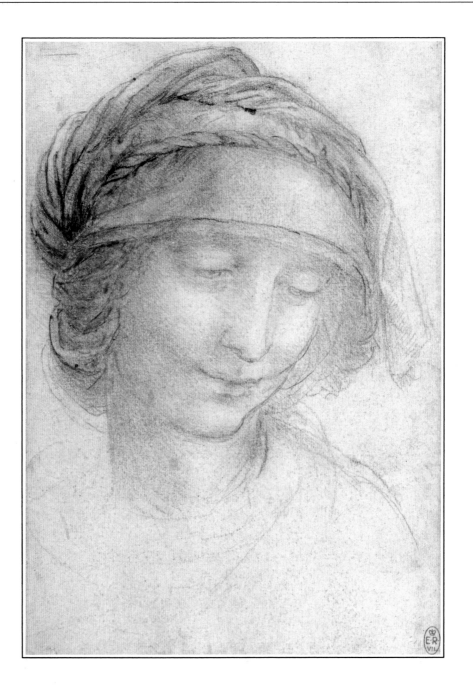

Detail

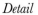 **St Anne**
Leonardo da Vinci

Black and white chalk

AT A TIME WHEN THE CHURCH was one of the main patrons of art most of the subjects painted by artists were religious. The walls of medieval churches provided admirable spaces on which to paint murals describing the events of the New Testament and the Lives of the Saints to an illiterate public. Educated people hung easel paintings, often of a religious nature, in their houses as a sign of their belief in and support of the Church's teaching. Like other artists, Leonardo chose appropriate models from among his acquaintances to play the parts of Saints and Madonnas. In this case he has picked a woman with an intelligent and tender expression to pose for Anne, the mother of the Virgin Mary.

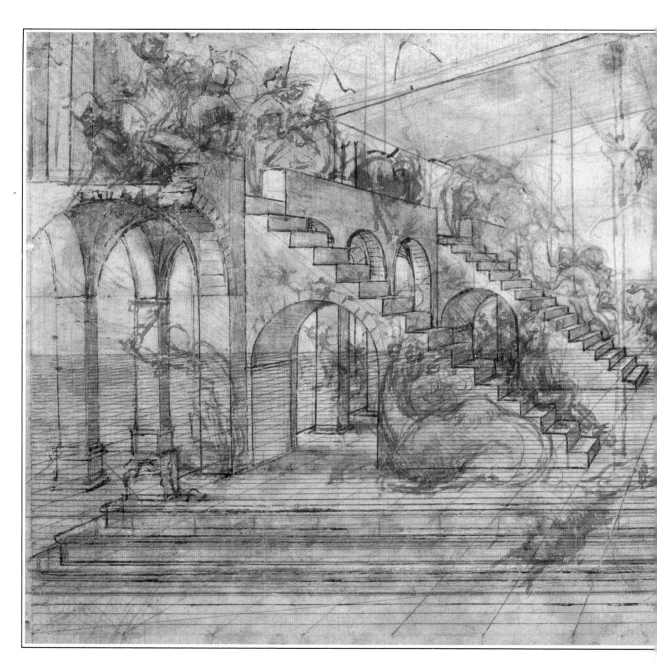

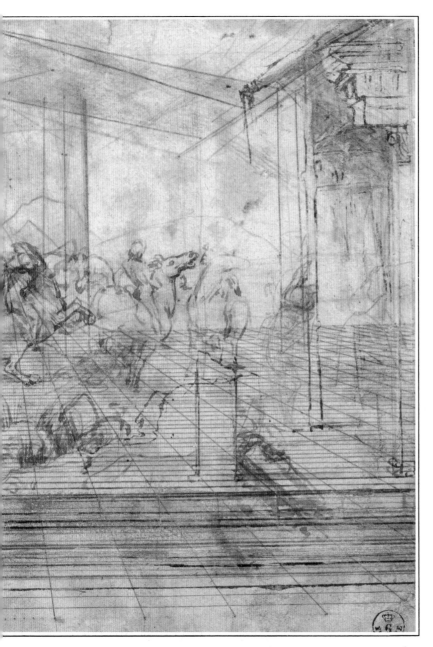

◁ **Architectural Study for the Adoration of the Magi**

Leonardo da Vinci

Pen and ink

THE EXPLORATION OF THE science of perspective was a Renaissance obsession only comparable to the study of anatomy. Leonardo, who was intellectually curious about every aspect of life, naturally made perspective one of his studies and applied it to his paintings and drawings. In this drawing he has worked out the perspective lines with meticulous care. The lines of sight carry the viewer into the back of the picture and the unfinished architectural detail on the right does the same. *The Adoration of the Magi*, which was never completed, was begun in 1481, the year before Leonardo was commissioned to work for the Sforzas, lords of Milan, for whom he designed an equestrian statue and painted a *Last Supper* in the Church of Sta Maria delle Grazie.

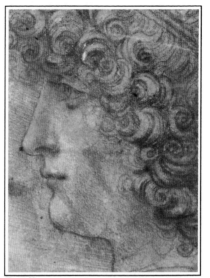

Detail

▷ **Two Heads**
Leonardo da Vinci

Red chalk

THIS DRAWING DEMONSTRATES admirably Leonardo's remarkable grasp of the character of his sitters. In the old man with his narrowed eyes, curving nose and toothless mouth there is, as well as the obvious signs of age, a feeling of the man's whole life lived with ruthless determination and sardonic humour. In the younger head, there is the resolution and optimism of youth. Both profiles have a fine linear simplicity and power which originated in the work of Pollaiuolo and Botticelli but which Leonardo turned into his own particular style. His interest in physiognomy was part of his scientific attention to all things, a distraction which often took him away from painting for months at a time.

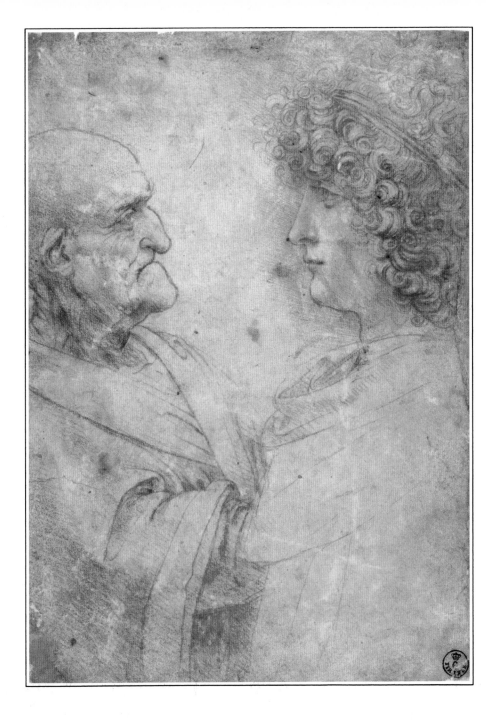

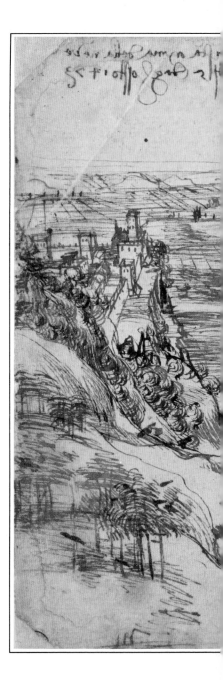

▷ Landscape, Dated 5 August 1473
Leonardo da Vinci

Pen and ink

LEONARDO'S INTEREST IN geology and botany led him to make many studies of the countryside in every kind of weather. Some of these studies were details of flowers and rock formations but many were also general views which were stored away as possible backgrounds for paintings. In this clear-cut pen drawing Leonardo is also exercising his knowledge of perspective, providing sight lines which carry the eye to the horizon and the distant and unfinished hills on the right. Leonardo's innumerable sketches were backed up by written notes of his observations. On his death these were inherited by Francesco Melzi, an Italian nobleman, one of whose family estates is now a public villa at Bellagio on Lake Como.

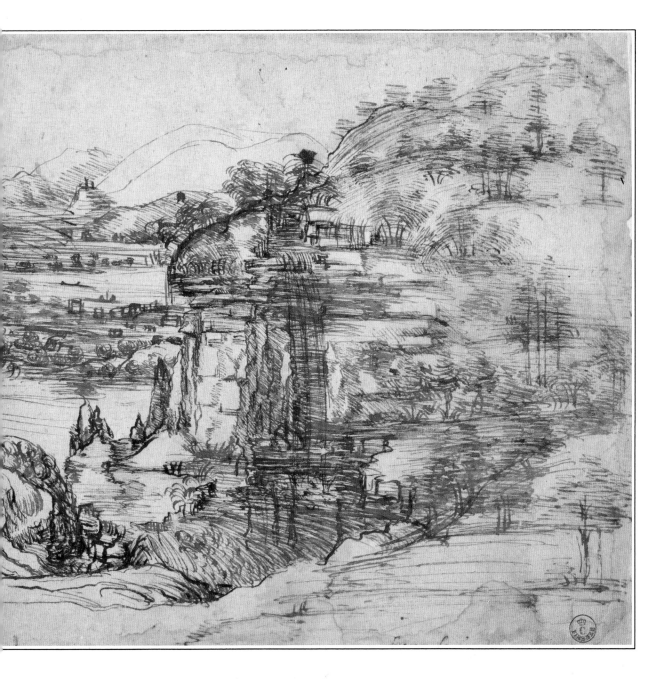

▷ **Adoration of the Shepherds**
Piero di Cosimo (1462-1521)

Pen and ink

THE INFLUENCE OF SIGNORELLI is clearly visible in the energetic lines and hatching of this pen and ink drawing by Piero di Cosimo. The confidence with which Piero has sketched in the composition shows that he belonged to that band of Florentine artists who were fully in control of the techniques originated by their predecessors. Piero di Cosimo, who was a pupil of Cosimo Rosselli's successful Florentine workshop, was put on the team that worked on Rosselli's commissions in the Sistine Chapel in 1481. While in Rome he met many other artists, including Leonardo, who had a considerable influence on his later work, helping him to break away from Rosselli's more conventional style.

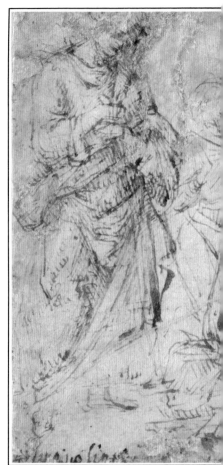

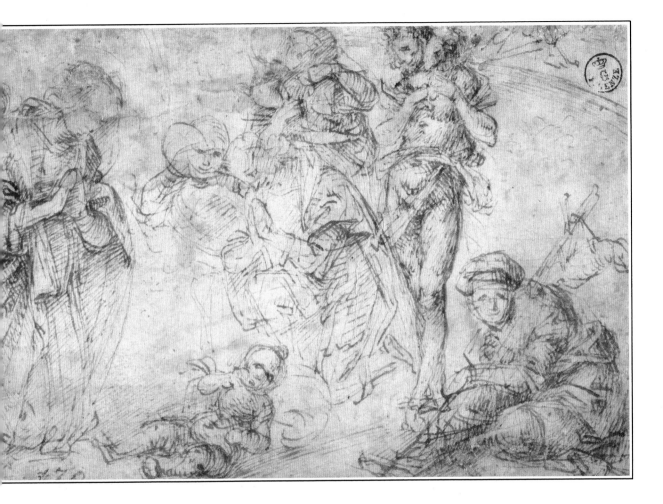

Detail

▷ **Study for the Cini Madonna**
Piero di Cosimo

Red and white chalk

THE IMPRESSIONISTIC WAY in which Piero di Cosimo has handled the line and shading in this study shows the growing confidence of Florentine artists in the new drawing techniques current among artists and draughtsmen in the 15th century; it also demonstrates the will of all artists, whatever their period, to break out into new ground. Piero di Cosimo, who was more talented than his master Rosselli, became much sought-after, not only for his paintings but for his special talent for designing the processions and festivals which the Medici and other powerful families sponsored for the entertainment of the populace. One of these was the famous Triumph of Death in 1511, which, though ephemeral in nature, enhanced Piero di Cosimo's reputation and was remembered for a generation as a great occasion giving credit to both sponsor and artist.

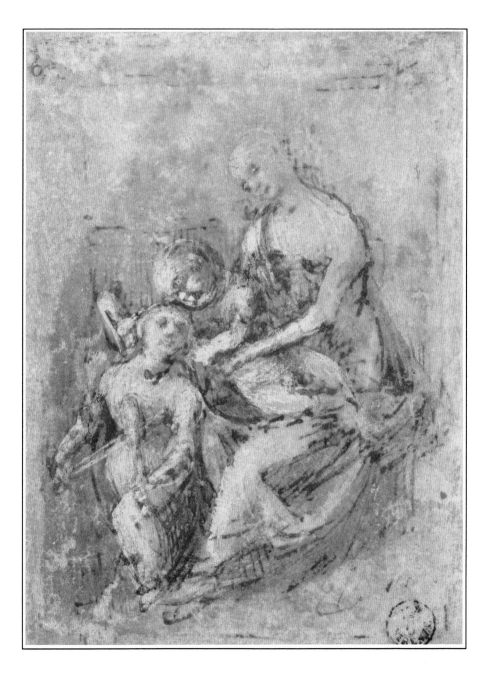

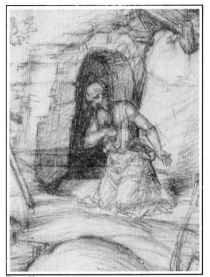

Detail

▷ **St Jerome**
Piero di Cosimo

Black and red chalk

PIERO DI COSIMO'S LANDSCAPES were highly individual and gave the impression of having been inspired not by nature but by fragments of rocks studied in his studio and used for an imaginary landscape. In this drawing of St Jerome, the saint plays a small part among the rocks in the foreground and the events of his life are given an unimportant background role. Panoramic pictures of this type were common during the early Renaissance; they allowed an artist to present several episodes from a Saint's life within one frame – a kind of moving picture of its time. As he grew older, Piero di Cosimo became more and more of a recluse, eating, according to Vasari, little but hard-boiled eggs.

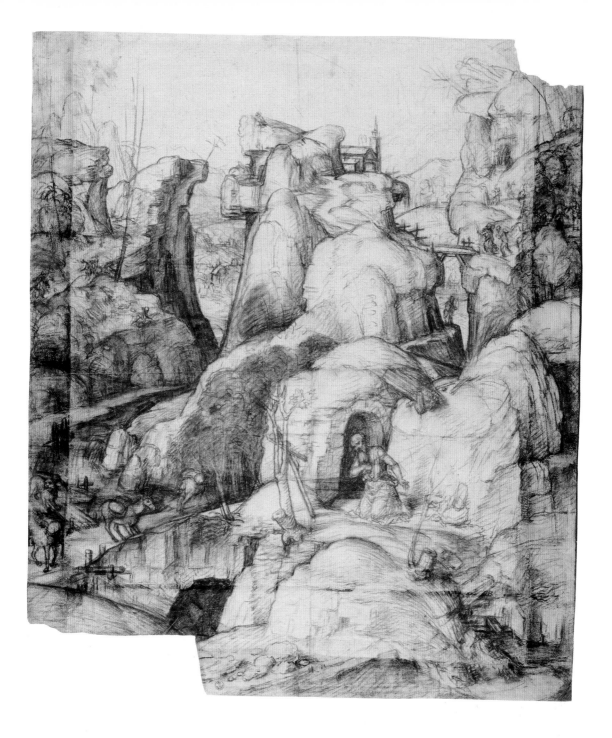

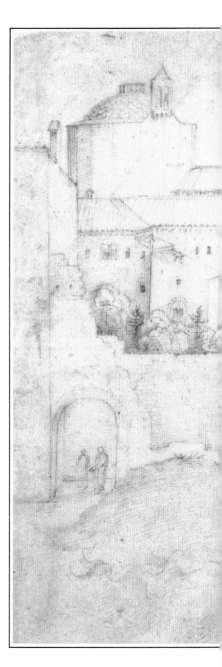

▷ **View of SS Annunziata**
Bartolommeo della Porta (1472-1517)

Pen and ink

FRA BARTOLOMMEO DELLA PORTA, also known as Fra Bartolommeo, was in the convent of San Marco when Savonarola's enemies stormed it and captured the friar in 1498. The experience had so profound an effect on him that he decided, in 1500, to become a monk himself, having already established himself as a painter. The *Last Judgement*, on which he had been working in San Marco in 1499, is said to have influenced the style of one of Raphael's great works, the *Disputa*, now in the Vatican. Ironically, Fra Bartolommeo had returned to Florence from a period in Rome because he was discouraged by the belief that, as an artist, he was far outstripped by Raphael. In this sensitive drawing of the church of the Annunziata, Fra Bartolommeo shows his feeling for architecture and landscape in the balance of the line and form.

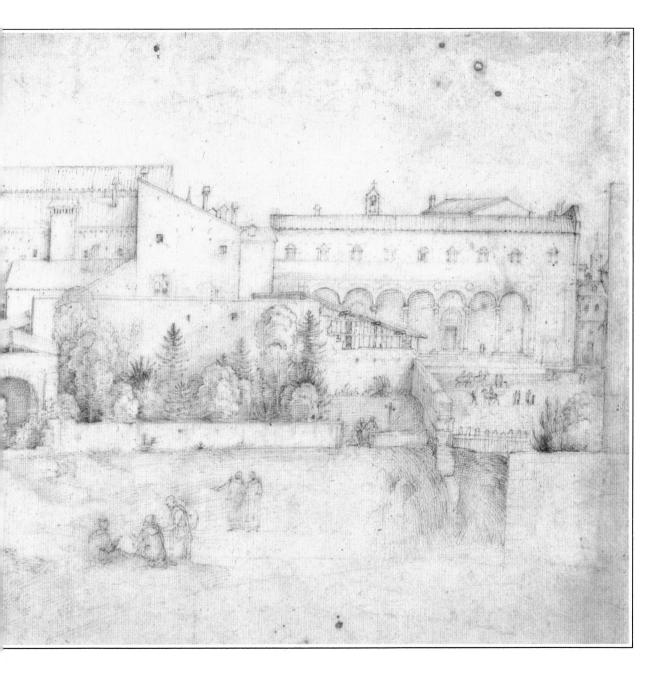

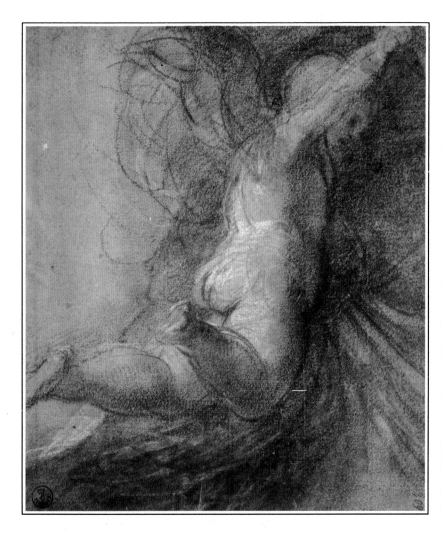

◁ **Angel in Flight**
Bartolommeo della Porta

Black chalk

THE RENAISSANCE ARTISTS'S
obsession with foreshortening and
perspective is well illustrated here
in Fra Bartolommeo's flying angel,
drawn with the soft *sfumato*
technique at which Leonardo was
a master. Here, the technique is
used to describe the folding
drapery by subtle gradations of
tone in the shading. Fra
Bartolommeo was himself
influenced by the paintings of
Giovanni Bellini, whose work he
had seen in Venice. In 1504, Fra
Bartolommeo became head of the
monastery workshop at San
Marco with Mariotto Albertinelli
as his assistant; together they
completed a *Last Judgement* begun
by della Porta some years earlier.
In 1514, Fra Bartolommeo began
painting a study of St Peter and
St Paul (now in the Vatican), but
he did not complete the figure
of St Peter and it was finished
by Raphael.

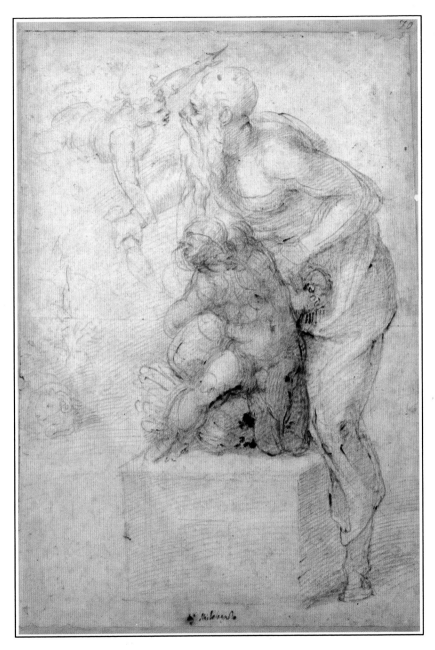

◁ **The Sacrifice of Isaac**
Michelangelo Buonarroti (1475-1564)

Black and red chalk

UNLIKE MANY RENAISSANCE artists, who came from humble homes, Michelangelo was the son of a well-to-do family who were not eager for him to become a painter/sculptor. He began his artistic studies with Domenico Ghirlandaio, but his strongly independent nature soon rebelled against the conventional learning of his craft and he left to work on his own, walking about Florence sketching in the many churches. In 1490 he joined other young artists in the Medici household and in that ambience he picked up the neo-Platonic and humanist ideas of the Florentine élite. By copying the work of other artists and drawing incessantly he developed his own incomparable style. This drawing shows his tentative approach in the search for inner form which he later drew with uncompromising directness.

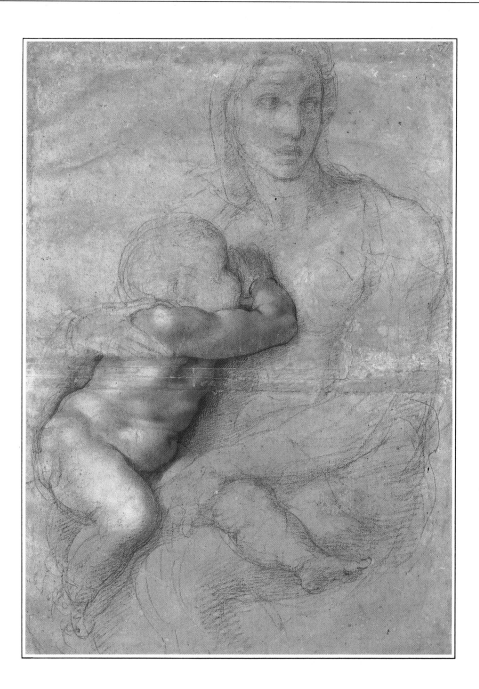

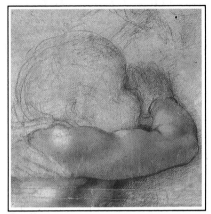

Detail

◁ **Madonna and Child**
Michelangelo Buonarotti

Black and red chalk

THIS DRAWING SHOWS how the careful searching of form by means of tentative line and shading was translated by Michelangelo into a firm, positive statement, as in the child's arm. The highlights picked out in white chalk and the half-tones in black and red chalk describe the anatomy of the child and are co-ordinated in a manner that produces a satisfying statement of form, irrespective of its anatomical correctness. Michelangelo's figure compositions, though religious in content, have a humanist and even pantheist feeling, especially in such works as the *Drunken Bacchus* (in the National Museum of Florence) and the frescoes in the Sistine Chapel in Rome.

Detail

▷ **Study for the Head of Leda**
Michelangelo Buonarroti

Red chalk

THIS DRAWING OF LEDA, who, in the Greek myth, was seduced by Zeus disguised as a swan, is a fine example of Michelangelo's drawing in his mature style. The modelling of the features of the face are fine and decisive and have the sculptural qualities which distinguish all Michelangelo's work. His career as a sculptor began with the marble bas-reliefs of *The Battle of Lapiths and Centaurs* (now in the Casa Buonarroti in Florence), but his personal style first flowered in the beautiful *Pietà* in St Peter's in Rome, commissioned by a French cardinal. Michaelangelo is believed to have left Florence to escape the worst of the troubles caused by the expulsion of the Medici and the rule of Savonarola, making his way to Rome about 1496. After returning to Florence in 1504, Michelangelo carved what was to become his most famous work, *David*, now in the Accademia in Florence.

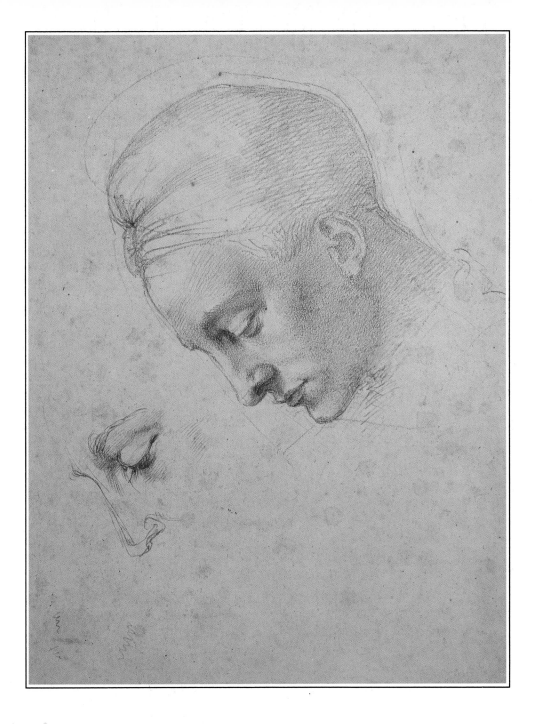

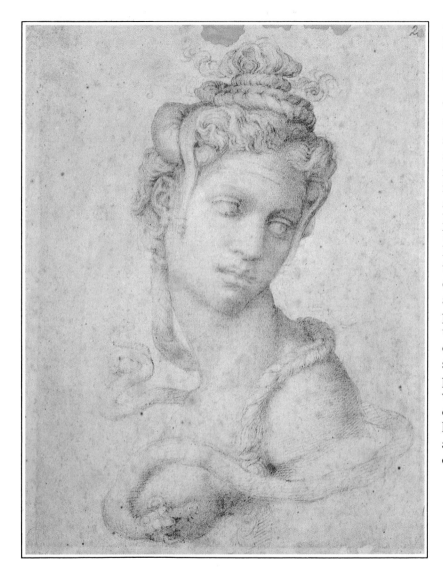

◁ **Head of Cleopatra**
Michelangelo Buonarroti

Red chalk

THIS STUDY OF THE HEAD of
Cleopatra, with its elaborate hair
style and entwining snakes, is in
an unusually tender mood for the
man of whom most people stood
in awe because of his terribilità or
ability to project a sense of power.
Like Donatello, Michelangelo
belonged to the new type of
Renaissance artist who was able
to imbue his work with a strong
emotional content through the
artist's understanding of the
psychology of the model. Later, in
the 18th century, the emotional
quality of many works of art
slipped into sentimentality and
pathos but Michelangelo, along
with Leonardo and some of their
contemporaries, knew how to
keep the balance in this as much
as in the technical aspects
of composition.

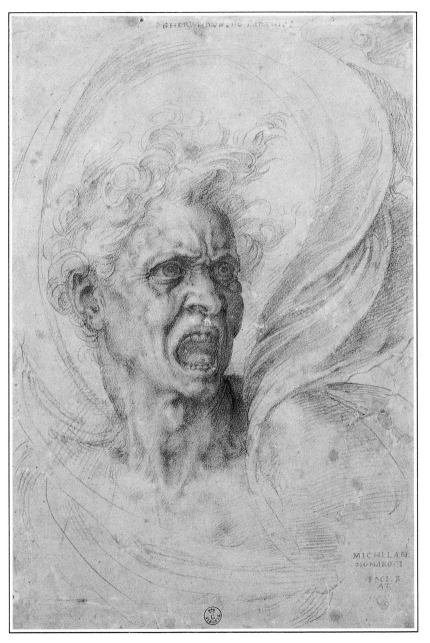

◁ **Fury**
Michelangelo Buonarotti

Red chalk

AS HE GREW OLDER, Michelangelo – a stubborn man of strong opinions – grew more and more impatient with those who did not share his views. While working in Rome on Pope Julius II's commission for a grandiose tomb – which, in the end, took 30 years to complete, though not on the scale originally envisaged – Michelangelo quarrelled with the Pontiff. Though they admired each other, their fiery natures caused a rupture that was not healed until Michelangelo was commissioned to make a statue of the Pope. It was soon after this that he was persuaded to paint the vaulted ceiling of the Sistine Chapel; here, working usually alone over a period of some four years (1508-12), he created a masterpiece, telling the story of the Creation in paintings inhabited by all sorts and conditions of mankind. This head was no doubt one of the hundreds of studies he made for the figures in his greatest work.

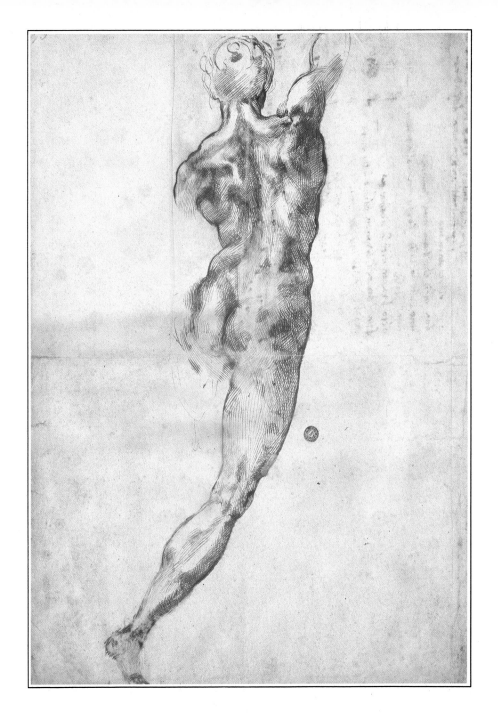

Detail

◁ **Study for Nude in the *Battle of Cascina***
Michelangelo Buonarotti

Red chalk

MICHELANGELO'S UNFINISHED *Battle of Cascina*, a mural intended for the Council Hall of the Florentine Republic, is known to the world only through the preparatory drawings. In this epic conception Michelangelo used scores of idealised nudes which personified the neo-Platonic and humanist ideas of man as God's focal point of ideal beauty and intelligence. In this context Michelangelo's figures are more than anatomical studies: they are expressions of the Renaissance idea of humanity – which saw men and women on earth as capable of great achievement in intellectual thought and spiritual beauty and able to lead others to higher planes of living. In later centuries, the Renaissance concept of humanist man became that of humanitarian man.

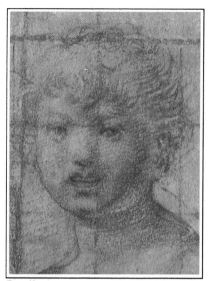

Detail

▷ **Madonna with Two Children**
Andrea del Sarto (Andrea Vannucci) (1487-c1530)

Red chalk

THE GENTLENESS OF Andrea del Sarto's style and his mastery of tone and colour made him the leading artist of his time in Florence while Michelangelo and Raphael were working in Rome. Though influenced by Michelangelo's dynamic style, Sarto was also interested in the incisive engravings of the German Albrecht Dürer, whose work was beginning to be seen in Italy. In this drawing there is, especially in the folds of the Madonna's dress, the clean-cut quality of gothic wood carvings which also appears in Dürer's work. The elongated figure of the Madonna gives a hint of the Mannerist style which was a feature of the end of the High Renaissance and was developed by Pontormo, Rosso and Vasari, all of whom were Andrea del Sarto's pupils.

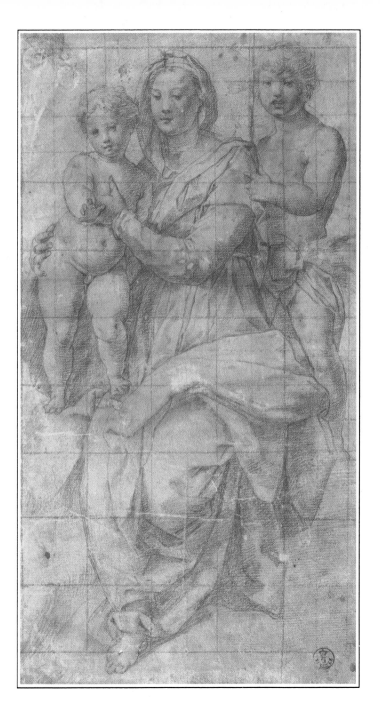

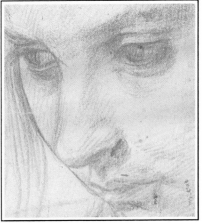

Detail

▷ **Study for the Head of the Magdalene**
Andrea del Sarto

Red chalk

THIS STUDY OF A THOUGHTFUL young woman, intended as a model of Mary Magdalene, has the delicate charm of much of Andrea del Sarto's work but retains the strength that he admired in Michelangelo's work. Sanguine (red chalk), in contrast to earlier pen and ink techniques, was ideal for the more rounded forms of the baroque style of the High Renaissance. It could mark a sharp accent and also provide the most subtle of *sfumatos* where forms merged into other forms almost imperceptibly, as in the Magdalene's eyes and lips in this drawing. Monochrome compositions were among Andrea del Sarto's special talents and he decorated both the Scalzi cloister and SS Annunziata church in Florence with this *grisaille* technique.

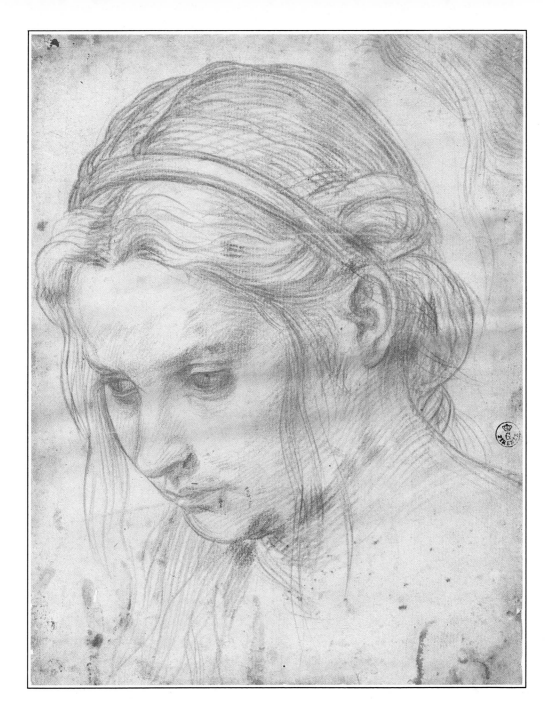

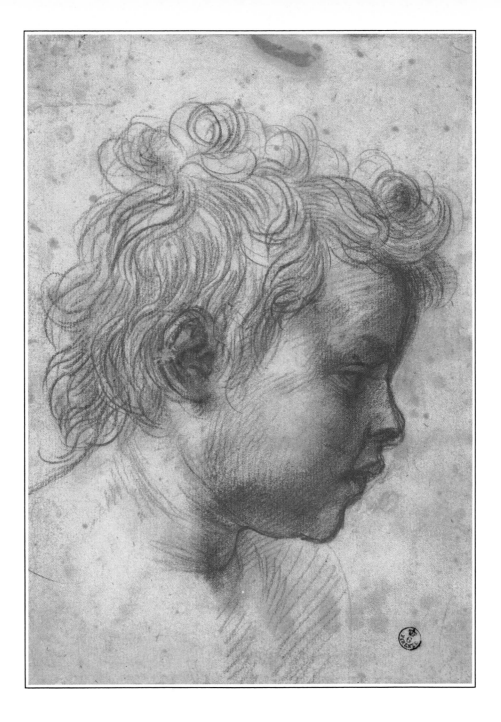

Detail

◁ **Study for the Head of the Young St John**
Andrea del Sarto

Red chalk

A RED CHALK MEDIUM suited Andrea del Sarto, who used it in this drawing both to describe the unruly arabesques of the child's hair and in the chiaroscuro of the face. He has also used hatching, thus combining several techniques in one drawing. Such was Sarto's fame that he was invited to France in 1518-19 by Francis I, who cultivated the arts and architecture of his kingdom. Another artist for whom Francis I was a patron was Leonardo da Vinci. Sarto's visit to France was brief, however, for his wife, who is reputed to have obstructed his career, obliged him to break his contract with the French king and return to Italy.

▷ **Male Portrait**
Andrea del Sarto

Black and red chalk

THIS LIVELY PORTRAIT SHOWS how skilled Andrea del Sarto was at creating atmosphere with a few strokes of his chalks. The outline, firm around the bony structure of the face, expresses the general form of the man's head, and the sensitive drawing around the eyes and mouth tell you about his character. Except for Michelangelo, Raphael and Leonardo, no other artist epitomises the spirit of the High Renaisssance as well as Andrea del Sarto who, with Bartolommeo della Porta, kept the Florentine workshops busy while more famous colleagues took on commissions abroad.

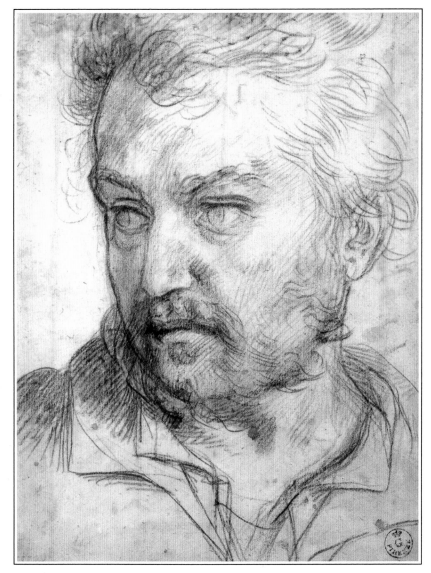

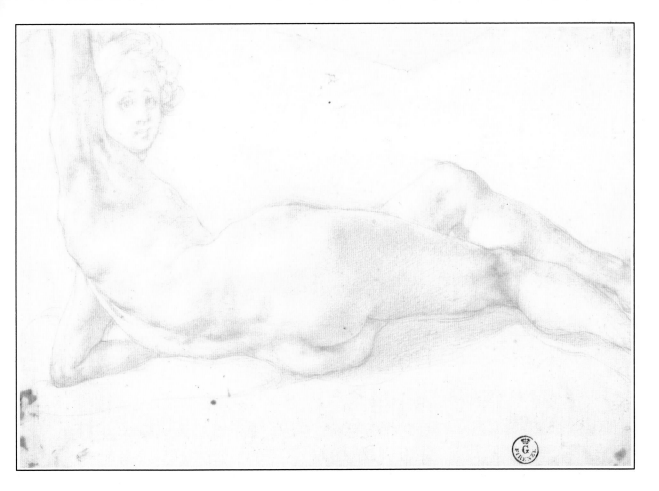

△ **Hermaphrodite Figure**
Jacopo Pontormo (1494-1556)

Red chalk

THIS FIGURE BY THE BRILLIANT and neurotic Jacopo Pontormo is in keeping with the artist's strange and withdrawn character. Born at Pontormo, near Empoli, Pontormo studied in Florence with Andrea del Sarto and felt the influence of Leonardo and Piero di Cosimo. At Sarto's workshop, he also came across Dürer, whose engravings were a novelty among the Florentines and whose angularity of line was adopted for a while by some artists. In this drawing it is the *sfumato* of Leonardo that is dominant, however, giving the figure a more emphatic form which, despite its title, does not appear to be obviously hermaphroditic.

Detail

▷ **The Three Graces**
Jacopo Pontormo

Red chalk

THE THREE GRACES in this drawing, which presages the development of Pontormo's Mannerist style, appear to be more hermaphroditic than the figure in the drawing specifically titled *Hermaphrodite*, to judge by their slim-hipped bodies and muscular torsos with undevelopped breasts. Such elongated bodies were a High Renaissance fashion, expressive, it was thought, of religious devotion and feeling; they culminated in the overwrought characters in El Greco paintings. The carefully observed and drawn line of the bodies in this drawing are in the Florentine tradition and hardly need the light shading to explain their form, for the line itself with its variations and changes in intensity tells all.

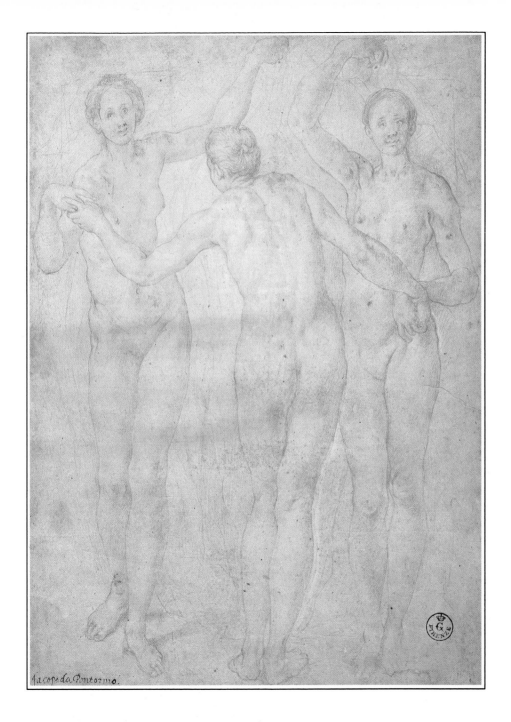

Iacopo da Pontormo.

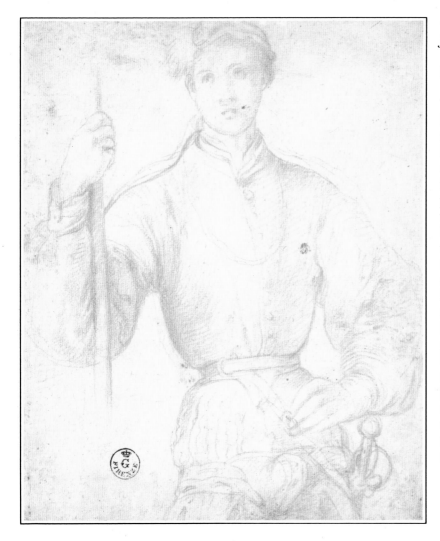

◁ **Study for a Halberdier**
Jacopo Pontormo

Red chalk

THIS ELEGANT YOUNG halberdier is drawn in the naturalistic manner of the High Renaissance, his indolent pose giving him the air of a fashionplate. He was, in fact, representative of a type who personified a culture that was winding down and was soon to become effete. Unlike the warriors of Paolo Uccello, with their warlike demeanour and accoutrements, this halberdier looks more like the scion of a ruling family who has gained an honorary position in a household guard. Pontormo's drawing, with its fine line and delicate chiaroscuro, shows that even in fading cultures art can triumph, often reaching a high point as the society that supports it attempts to convince itself that it is not endangered.

▷ **Young Man with a Turban**
Jacopo Pontormo

Red chalk

THIS DRAWING IN A Mannerist style shows the new direction which Pontormo and Rosso Fiorentino were giving Florentine drawing. The long lines and elongated anatomy have a gentle and elegant grace which makes the sex of the sitter ambiguous. This was the spirit of the latter days of the Florentine Republic at a time when its status and position as a centre of finance and commerce was declining. The discovery of America in 1492 had created a threat to the east/west trade routes that ran through the Italian peninsula, and though it took another hundred years for the effect to be felt, the writing was on the wall.

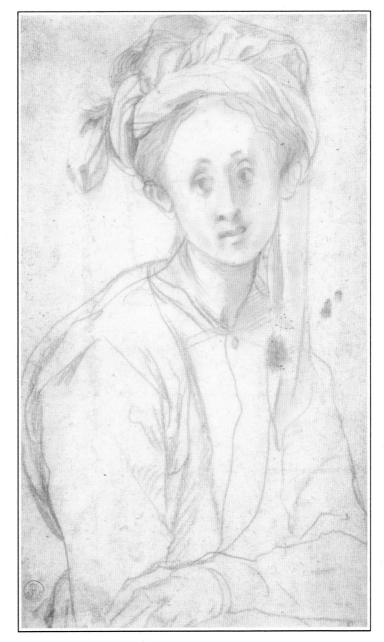

△ **Player Tripping Up**
Jacopo Pontormo

Black chalk

THIS IMMENSELY SENSITIVE nude study of a player who has fallen over is almost minimalist in conception, with the drawing so faint that it almost vanishes. Perhaps this was a projection of Pontormo's own feeling of helplessness as he grew older in a population whose average age was not much more than 20. The man who had been befriended by the Medici and decorated many of the major churches in Florence as well as the Medici villa in Poggio now felt isolated and neglected. Like many former celebrities, he began to write his autobiography in which he expatiated at length on his work and the state of his health.

▷ **Male Nude**

Rosso Fiorentino (Giovanni
Battista Rosso) (1494-1540)

Red chalk

ROSSO FIORENTINO WAS a friend
and work colleague of Pontormo
and also a pupil of Andrea del
Sarto. As can be seen in this
drawing of a nude male figure he
was, with Pontormo, one of the
leading Mannerist painters of his
age, giving his figures the long
lean look that was fashionable. In
this drawing, there is a certain
violence of movement and facial
expression that reveals the
tensions at work in a Florence
threatened by the ambitions of
the Pope and of the rulers of the
powerful countries of northern
Europe which were seeking to
control the princedoms of the
Italian peninsula.

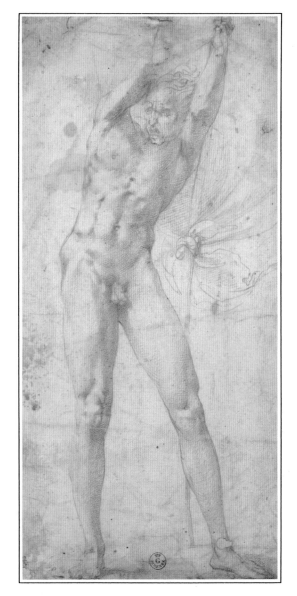

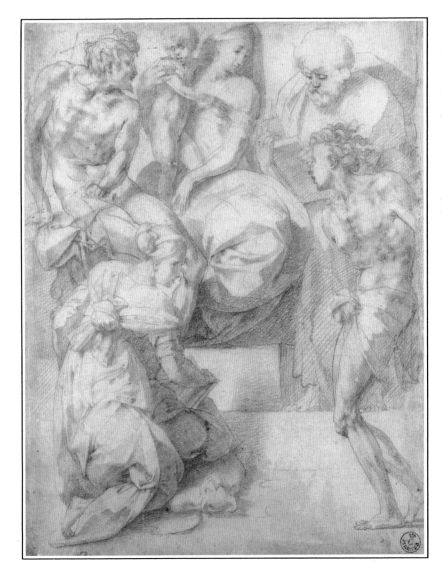

◁ **Madonna and Child with Saints**
Rosso Fiorentino

Black chalk

THE ANGULARITY OF the folds of the robes worn by the Madonna and saints in this drawing suggests the effect of Dürer's engravings on Andrea del Sarto, who was Fiorentino's master. The violent gestures of the nude male saints are all Fiorentino's own, however: it was this treatment of holy personages that made one Florentine patron turn down Fiorentino's work on the grounds that his angels looked like devils. The intention of the composition of this drawing is to make it into a *conversazione* picture in which the figures are grouped together, as in a conversation, instead of being separated, as in traditional altarpieces.

▷ **Magic Scene**
Rosso Fiorentino

Red chalk

THE REVIVAL OF INTEREST in magic in 16th-century Italy was due in part to the writings of the philosopher Pico della Mirandola, who wrote that magic could be justified in a neo-Platonic and humanist society if it was an expression of man's intellect and dignity and not just witchcraft. When the Church came to accept this apologia magic became permissible: what, after all, were miracles except magic of the right kind? Fiorentino was no doubt aware of the public interest in magic, but was also wary of the powers of the Church through the Inquisition and was torn between a desire to exploit the public's interest without falling foul of the Inquisition. This may explain the innocuous nature of the scene in his drawing.

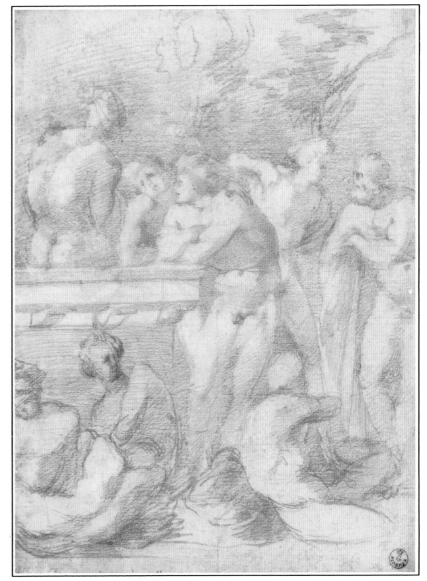

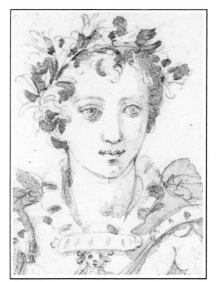

Detail

▷ **Day**
Giorgio Vasari (1511-74)

Black chalk and wash

GIORGIO VASARI WAS THE GREAT, though sometimes unreliable, chronicler of the artists of the Renaissance. He was a painter and a draughtsman who had trained with Andrea del Sarto and Pontormo. His hero, however, was Michelangelo, whom he saw as the summit of the progress of art since the Dark Ages. Without Vasari's Lives of the Most Excellent Painters, Sculptors and Architects, little would be known today of the lives of the artists whom the society of their day regarded simply as slightly superior artisans. Vasari dedicated himself to promoting the artists as a special and higher type of being worthy of having their lives recorded. His own paintings decorate the Palazzo Vecchio in Florence and his own house at Arezzo.

Giorno figliuolo dell' Herebo
et della Notte
21.

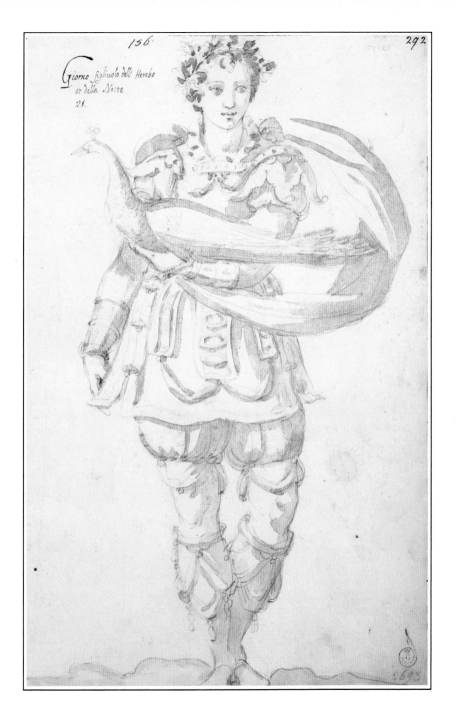

▷ **Frontispiece for Il Torrentino**
Giorgio Vasari

Pen and ink

VASARI, WHOSE EDUCATION was due to the goodwill of Cardinal Passerini, guardian of two young Medici children, benefitted from his Medici contact by earning their patronage thoughout his life. His work for the ruling family included paintings and allegories glorifying their lives. His best contribution to their world was, however, not art but writing. His *Lives*, published in 1550, supported the neo-Platonist and humanist ideas held by the Medici that progress should be measured by the lives of exceptional men. In the case of *Lives* the famous men were the artists who had thrived under the cultural patronage of the Medici during the 15th and 16th centuries.

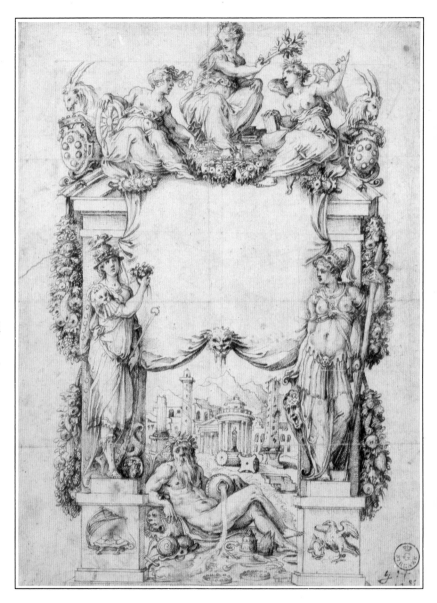

ACKNOWLEDGEMENTS

The publisher would like to thank the following for their kind permission to reproduce the paintings in this book:

The Royal Collection © 1996. Her Majesty Queen Elizabeth II 34, 35; **Photo Scala, Florence** 8, 9, 10, 11, 12, 13, 14, 15, 16, 17, 18, 19, 20, 21, 22, 23, 24, 25, 26, 27, 28, 29, 30, 31, 32, 33, 36, 37, 38, 39, 40, 41, 42, 43, 44, 45, 46, 47, 48, 49, 50, 51, 52, 53, 54, 55, 56, 57, 58, 59, 60, 61, 62, 63, 64, 65, 66, 67, 68, 69, 70, 71, 72, 73, 74, 75, 76, 77, 78

Every effort has been made to trace the copyright holders and we apologise in advance for any unintentional omissions. We would be pleased to insert the appropriate acknowledgement in any subsequent edition of this publication.